To Al Glowasky —

Best Wishes and Peace

George Landen Bristol

June 3, 1992

VISUAL VOICES

BETWEEN MOUNTAINS AND ME

Photographs and Poems
by George Lambert Bristol

Preface by Lloyd M. Bentsen, U.S. Senator

PREFACE

By Lloyd Bentsen

George Lambert Bristol has an eye for beauty and an ear for the perfect word to convey his ardor. He loves the West, with its stirring vistas and its lively people. He enjoys the outdoors, whether a fog-shrouded forest, a sun-drenched lake, or a snowy backwoods trail. He is a keen observer of how we live and what we feel.

Through his photographs and poetry, he portrays moments of deep emotion and simple pleasure. The words are counterpoint to the pictures, able to stand alone but coming together in powerful synergy.

I know George Bristol from the world of politics, where he is engaging and energetic, even pushy. This book reflects a different side of him—serene, introspective, detached. His images and insights on these pages are timeless, far removed from the ephemera of politics. Yet they are also real and immediate to the reader.

This book ranges both far and deep, capturing the vastness of nature as well as the intimacy of human feelings. It is a work of love and of art.

INTRODUCTION

For thirty years I have had an unbroken love affair. Nothing in between my first glimpse of Glacier Park's peaks, rising from the plains, has deterred my wonderment at their permanence in my musings.

Crossing the bouldered plains; then snaking above uncharted rivers; dropping down into the Flathead Valley was not by choice, but simply because that's where the Great Northern stopped in early June in 1961.

In the first fresh scent of pine, I shook off the prospect of three months from home and felt no lonesome.

This time and this place was not to grow slowly on me, but sprang full born into the category of first puppy or prom kiss. Without pondering or acceptance, it was forever. From that moment, it would fill the remembrance well to the brim.

That did not mean every thought would flow Muir-like over cathedral trees or setting suns. The first particles in my Montana spectrum are rooted squarely in the juke box-lit countenance of Mrs. Freda's face at the West Glacier Bar. How better to cement a lasting love affair than to stand in the entrance of an out West saloon and exclaim that everyone inside shall henceforth be memory's best friend.

Even the juke box records were conspirators, playing ever-to-be-remembered melodies over the din of canned Olympia greetings.

Douglas, Bruce and Bryan, bonded as kindred spirits from across the country, remain unfaded images, laughing in the easy manner of little men—first time out bold—establishing manhood in the foam of a fresh drawn beer, yet thankfully assured that in this middle of nowhere, lack of yesterday's friends and family would not be bothersome.

Freda, through store-bought spectacles, read proper identification from several feet away. Surrogate mothers may on certain occasions allow their near grown to partake.

From there it was off to McDonald Lake Lodge to establish territorial imperatives. Here and elsewhere tucked among lodge poles and glacier lakes were the summertime residents, mostly Minnesota girls, who were experiencing their first brush with feelings without blushing.

No matter that soon each would have to go about daily chores that they would rebel against at home. At that moment these clerks and cooks were maids in waiting to be courted and protected and certainly shielded from the need to write longingly home to whomever.

All this took place in the dark of the first night and, while the events still lay easy in the backwaters of my mind, they do not compare to dawn.

There is something compelling about first times in first places that make the soul shake the body, no matter how beer battered, to awake and discover.

Rising from McDonald Lake into copper blue, sentinels still snow-capped spread against the horizon.

Out of the Park Service cabin and into pine air—not a hint of industry. No smokestacks, save for the end of the pot belly beginning to bubble coffee.

Forgotten were the frettings of leaving just about the most perfect Chi Omega at the train yard in Fort Worth; mother's tucking of extra dollars and a granddaddy's admonition to read Browning on the long train ride and thereafter.

This was to be my time in my place in my mountains.

Bruce's coughing convertible could, with some urging, take me to them. Along Going-To-The-Sun, past Heaven's Peak, up to Logan's Pass. There on top of my newly possessed horizons spread the rest of the world. As surely as puberty came somewhere between 17th Street and junior high, I stood in blue jeans, new boots and manhood. No one can stand at the summit of peaks that run to oceans without shedding layers that bind to boyhood.

Certainly only the bravest of men could fight forest fires, rescue tourists and conquer winter-worn trails in the wilderness area of Glacier.

A wilderness it seemed, leaving the mountains down to the wind stubbed plains, not to mention the fact that it was to hell and gone from Lake McDonald Lodge and the waiting arms of an already sun-browned Miss Whatever College who was there the night before.

While I will always look back through those first feelings with glances of lasting welcome, it is to Many Glacier Valley that I hasten whenever there is need to repair.

Like a magician's sleight of hand, the valley is not there; then at an aspen turning it reveals the gray and black of the Garden Wall. Never the same at any given setting of the sun, but a moving train of barren beauty. Mountains carved by glaciers, lakes worn by glacial retreat and on every hillside the flowering beds from glacier silt.

It was more. The nostalgic sense of belonging, man and mountain together. Sherbounne, Swiftcurrent, Joesphine and Grinnel linked and ran to the falls at Morning Mist.

The mountains swelled to the surface the need to share beauty which would surely be summer short and then be moved to the category of now and again. Upon reflection that is what she must have felt.

She was not perfect, but silhouetted and shadowed in the changing moods of mountains, I could not or did not want to know the difference. For in reality she was the focal point of all that lay in that special setting.

But even in the midst of perfection there were imperfections. Death rode the sunset and doomed a perfect day. He came in the form of someone wanting to conquer the mountains without first understanding them. Only eagles can drop their young from peaks and either watch them soar or dive to their rescue.

Yet youth until well into manhood cannot contemplate death. It is to be dealt with in a murky time never to come. For two days we searched for life, but found death at sunset. For a moment the mountains held no beauty.

By sunrise the night had washed the stain along swift currents and out onto the plains. Somewhere in Minnesota someone screamed, but as the forest falling creates no sound, there was no more pain.

From that moment of sorrow mixed with that night of mountains and the not quite yet touching pleasure of her, there came a blending which to this day I do not completely fathom.

In that split second of my mountain time, there had been death, love and beauty. For the first time it had all run together and spilled out the other side of the spectrum into colors that I had never seen before.

For all of my days I will be haunted by the realization that there is pure blue beauty in Montana mornings. That there is complete solitude in Montana midnights and that there is joy wherever memory glances. Yet when the memories of that soft summer are partner to the missing, then mountains, mornings and midnight become mystical and magical—an anchor for my soul.

As a footnote to my experience, there were the Indians—Blackfoot and Blood—who lived on the outskirts of Glacier Park and for all intent and purpose on the outskirts of our national conscience. Once proud warriors wait for drinking nights and forest fires. One to make them immune to the degradation that weighted upon them and the other to put a little extra money in their jeans in order to pay for the drink.

They were a downcast and bitter lot. Their tarpaper shacks were little protection from the arctic winters and were a constant reminder that Custer had won the war.

They, too, are a reminder that there is an obligation to seek a sharing with man and nature. There can be room enough for both. Particularly if we set aside forever enough space to gather, unfettered in the drift of the mundane.

There have been other times filled with people, places, politics and faces. Some more relevent and lasting. There have been other amusements and presents under the memory tree, but none have or should replace that one time when everything flowed together. For it is that time undefined that gives continual definition.

There must be a top of the world above the storm. Mine are mountains in Montana. In between is the rest of me.

TABLE OF CONTENTS

Published by Leisure Time Publishing, Inc., a division of Heritage Worldwide, Inc., Dallas, Texas.

Publisher: Rodney L. Dockery

Book Design: Sandra T. McGee

Manufactured in the United States of America.

First Printing

Printed By:
Heritage Worldwide, Inc.
9029 Directors Row
Dallas, Texas 75247
Telephone: (214) 630-4300

This book is for

my family

and

all those who love

the National Parks

ACKNOWLEDGMENTS

There is no adequate way to put in a paragraph or two the appreciation for those who helped make a project like this possible. So I'll do the best I can.

My literate parents and grandparents planted the genes. Several high school and college teachers brought them to the surface. Speaker Jim Wright helped me get a job in Glacier Park, Montana in 1961. The National Park Service kept it in good shape for me for whenever I need to take time out.

Senator Lloyd and B.A. Bentsen, Bernard Rapoport and a host of others kept encouraging me. Several secretaries, but particularly Charlotte Hawkins, waded through the redrafts. Finally the people at Heritage Worldwide said, "Let's do it!"

SUMMER MUSINGS

This is the season that suits me best,
When high meadow pools fill, then crest,
Cascading forth from mountain breast,
Leaping to streams that flow to the West
Out to the booming sea.

In this season are those special days,
Caught on spikes of bright golden rays,
When the cloud hidden sun roams ablaze,
Then disappears from my fading gaze
Down to the booming sea.

Yet in that time between sun and moon,
Night birds begin to blend in tune.
Young folks yearn to be kissed soon.
It's then I think of a long past June
When love first bowed to me.

What if that meeting were other than here?
Would so much beauty reappear?
This summer season held so clear?
Or just a passing tide of the year,
Meaning no more than winter to me?

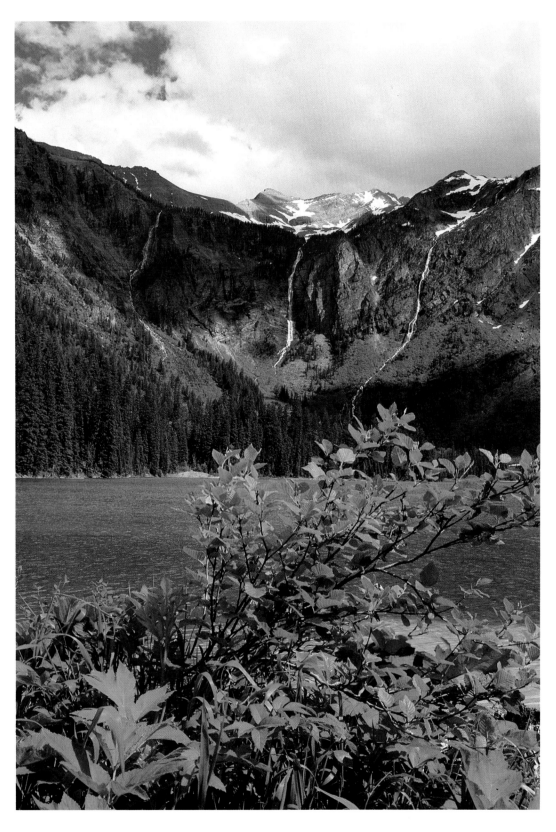

Avalanche Lake, Glacier Park, Montana

WINTER BELONGS TO THE POET

Unnatural, the poet's harvest,
Taking seed in the winds of spring
Or in the afterglow of summer.
No real rhyme flows, until the melancholy
Tumbles over the horizon
Into Winter's first embrace.
The sun laying on its side
Bleakly begins to slide through
Clouds layered in scudding gray.
The original chill touches the heart.
Moving the mood to change
From the restless shifting of autumn
To the steely realm of night.
It is the drawn out dark lack of sound
That leaves the soul to seek
The meaning of the unmeaning.

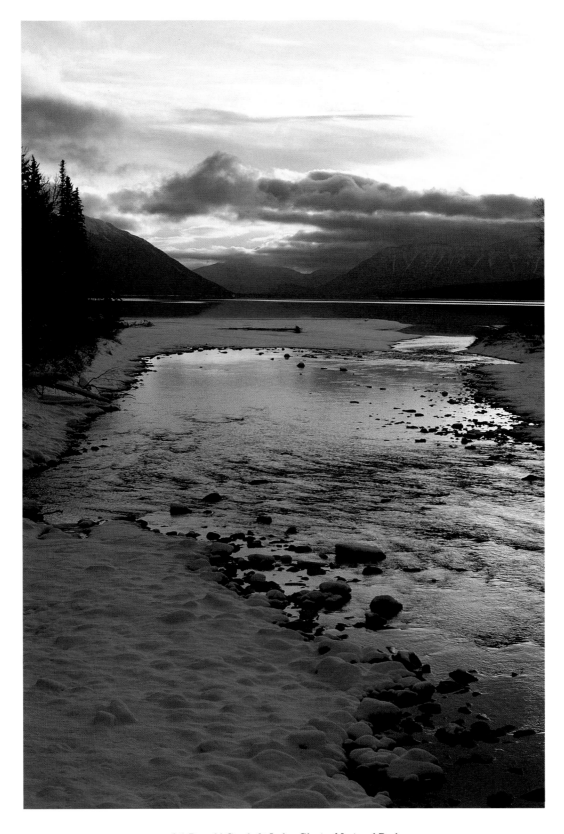

McDonald Creek & Lake, Glacier National Park

NAPI'S WINTER—FOR JIMMY, MARK AND JENNIFER

When the tribes depart from Napi's mountains.

When the great Grizzly moves to sleep.

When the eagles watch the rivers.

When the Walls no longer weep.

When the snows move through the valley,

Cap the peaks in silent white,

Brace the streams in icy stillness,

Wrap the trees in silvery quiet.

Then usher forth the Snow Queen,

Draped in robes of glistening splendor,

Calling forth for Snowslip's Zenith,

Calling to the hosts of winter.

See her dancers on the ridges;

See her bowmen bow and sway;

Listen to her song of silence;

Harken to the King of Day;

Harken to the Prince of Night,

Sparkling in their brilliant glow,

Gleaming in their muted passing

Over this Kingdom of the snow.

But to see this stately realm,

One must move through weighted branches,

Track the deer down snowy pathways,

Follow the crow with skyward glances,

Then stop at a silent crossing,

Listen for the bells of the wind,

Tinkling in deep forest,

At the edge of Glacier's glen.

There perhaps you will see

In the sparkling valley runs,

How the tribes found enchantment

In the nights of Sleeping Suns.

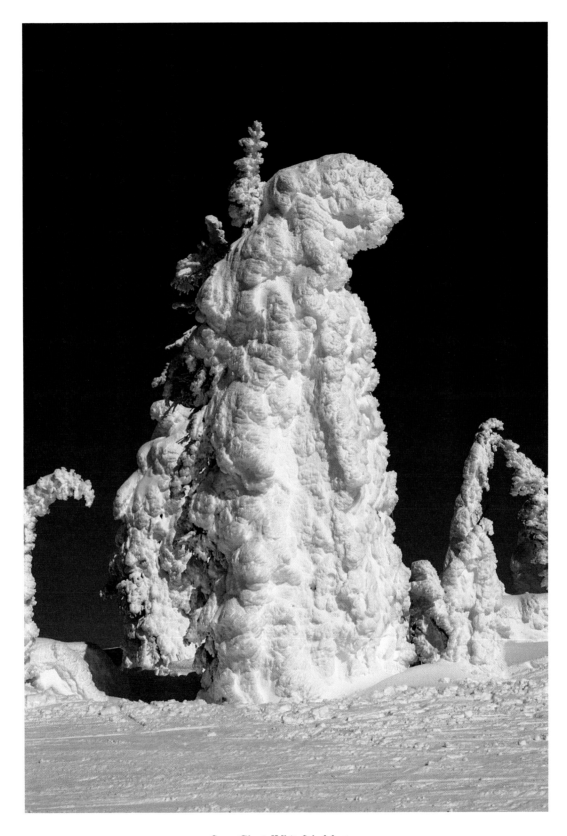

Snow Ghost, Whitefish, Montana

MCDONALD CREEK

Some friends question,

 Others proclaim

 That nature's beauty can't

 Replace hard won fame.

 Yet here I stand

 In the glow,

 Watching cascades

 Plow through the snow.

 The mule deer has no fear

 That I will lay,

 Platting strings

 Across his way.

 Deep within the forest,

 Silence begins to bend,

 Weaving through sounds

 That let the mind pretend

 That I am here alone

On the blue side of paradise.

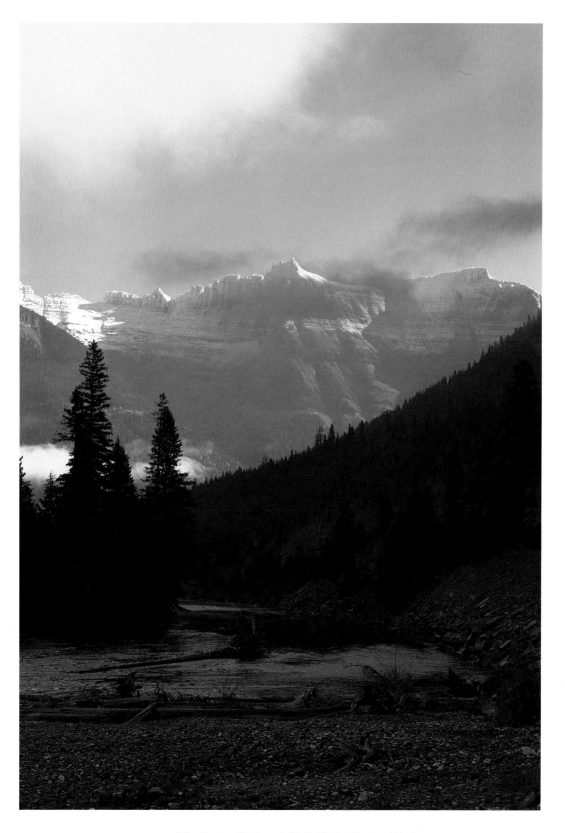

The Garden Wall, early Fall, Glacier National Park

THOSE WHO HAVE NEVER KNOWN MAGIC

If there be those who have never known
Or could never bring themselves to believe
In the fathomless mysteries of magic,
Then they must come to the Montanas.
Observe the Storm King ply his trade.
With sleight of hand he whisks a peak
From view with a cloudy handkerchief pulled
From a perfect indigo hat.
Then as adroitly he puffs away the veil
Turning crevasses from blue black to ghost white.
Peaks that have moments before
Lain in lazy silhouettes
Can leap toward heaven
With a lightning braided halo,
Then disappear for hours
In the whispering mist of stage fog.

> Thus when the weight of neighbor
> Grinds the last tree to pulp
> And the bark of the civil humdrum
> Cries in constant pain
> Turn your eyes toward high ground
> Seek the wind among the pine
> Await the Storm King's entrance,
> Leave reality to the blind.

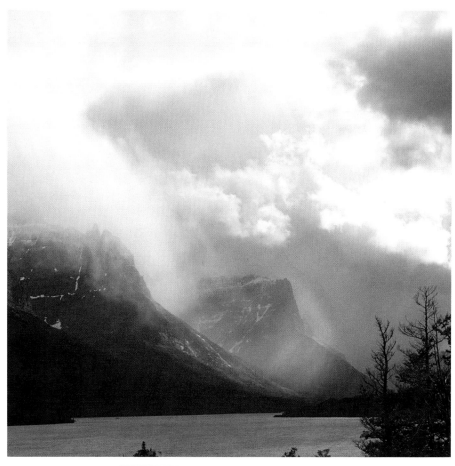

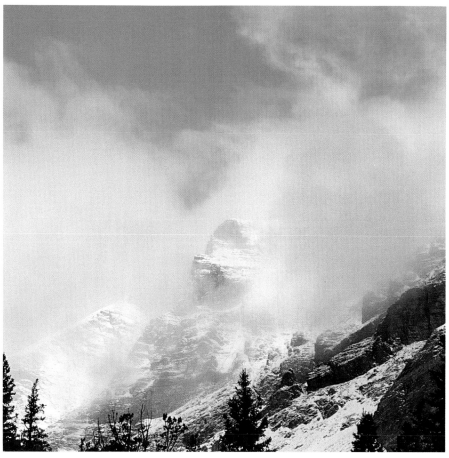

Cloud formations, Glacier National Park

DEEP CREEK PUT IN

It has occurred to me
That I will never sleep
Upon this shore again.
Not that it will be important
In the scheme of things,
Only in dreams
Now and again.
But in dreams it has occurred to me
That I should have been of the sea.
Cast long ago upon this shore,
Weather worn and weary.
I am the latter
But not by the sea,
And the former
I shall never be.

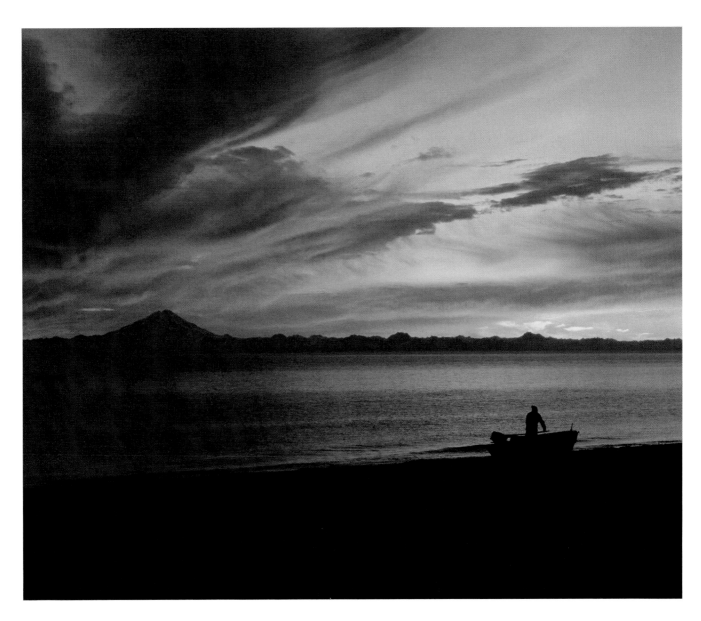

Cook Inlet sunset, Alaska

MANY GLACIER VALLEY

For twenty years I have appeared
Upon this wind worn knoll
To wrap myself in ice and wind
To silently repair my soul.
At first it took a day or more
To still the black savage
That burned a raw sore
And fired a thundering rage.
Now in the course of a millisecond
I begin to purge the grime
That dam the pores of my psyche.

This is the anchor of my soul,
The mistress of my fantasy
That does not fade with time
But beckons stronger
Than any siren's song.
Then the question becomes,
Is this heaven?
For surely there's a hell
That grinds the dreamer
To ruinous final dust.
Believing this to be perfection,
Then to here my final rest.
What need for a cosmic heaven?
Then heed my request:
I am earth born and bred
I do not seek the stars
Let sun heal the pain
Let wind smooth the scars.
When a thousand eons pass
Over the spans of generations
Then to here seek my soul.
Look to the rain splashed sunlight
Gleaming in silvery dancers
On the edge of the roving stream.
Somewhere in the crags and shadows
I will repose and call your name.

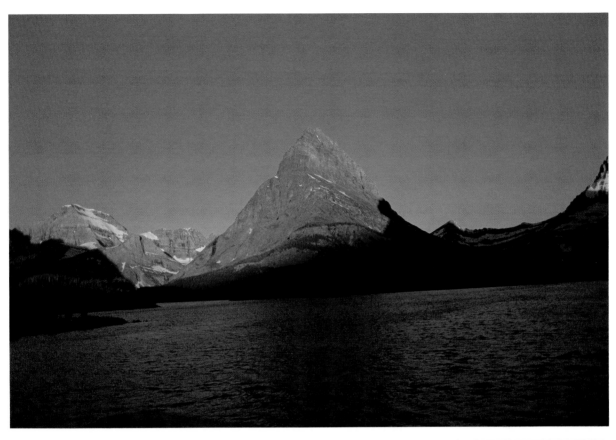

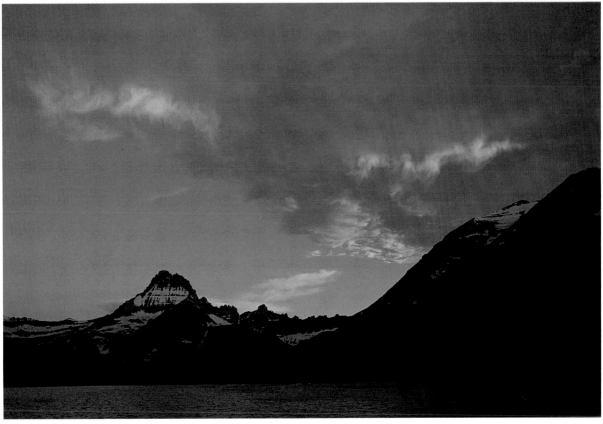

Sunrise & sunset at Many Glacier

15

GLACIER FALL

No painter can pour into blend

Enough color to capture

The brilliance of first snow

That sugar plums the ridges

Backlit in Autumn blue,

But this October, I'll try to

Capture in my mind's eye,

From nature's paint pot,

Enough to supplement

Winter's somber shades.

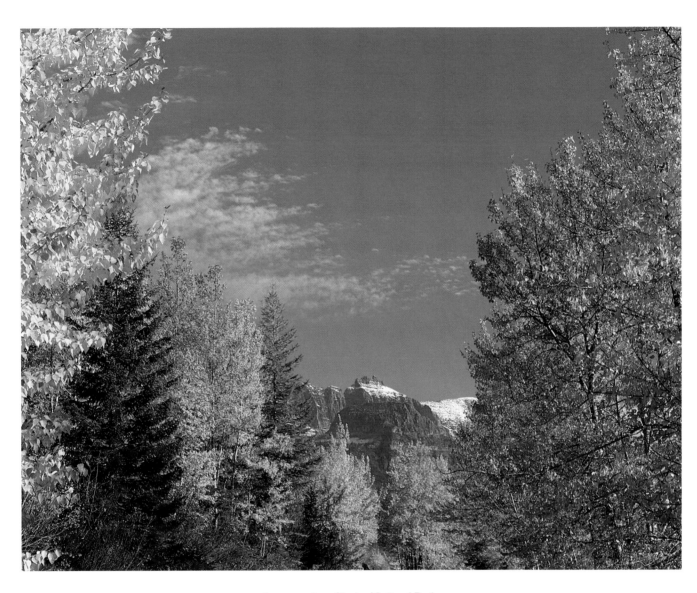

Autumn colors, Glacier National Park

SPRING SNOW RUNNING

The mountain snow has fled,
At first playing hide and seek
With the sun.
But when his pursuit became
Too hot,
The snow began to run.
Some claim to have seen her in the valleys,
Others, lapping at the shores.
I suspect we will never know
Or see her again—
But next year her daughter will
Blind the sun,
Making love to the mountain.

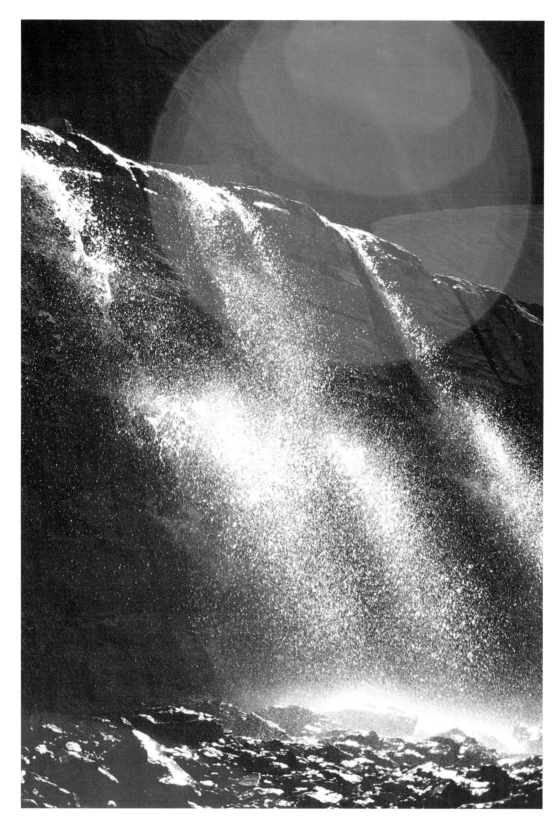

Waterfalls below Sperry Glacier

AUTUMN LEAVES

These autumn fans of blade and vein,
Muted in fall filtered light,
Are nothing more than that alone,
Seasonal ornaments
Signalling death and renewal.
Yet when laid aside and remembered
In their time and setting,
They become the color key
To a memory box.
That is the essence of every picture
Or line of rhyme,
Pulling back the shadowed past,
Adding more than imagery.
It is the connection between
Now and a moment that was kind
To the mind's eye.

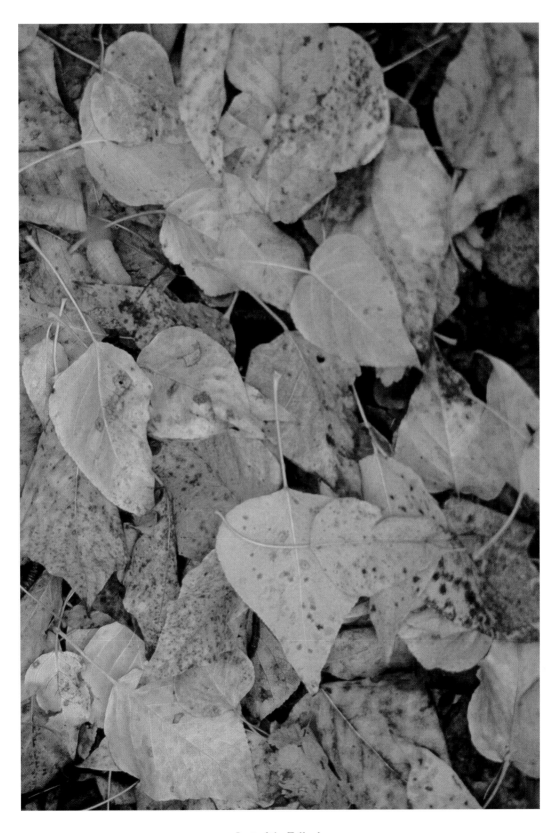

Last of the Fall colors

BIG MOUNTAIN RAINBOW

Fill the white with skiing colors,

Blue hats with yellow balls,

Red jackets, orange overalls,

Stately greens and ragged jeans,

Peacocks pinkly preening,

Cuties carrotly careening,

Coloring the white

With a human rainbow,

Crocheting patterns in the snow.

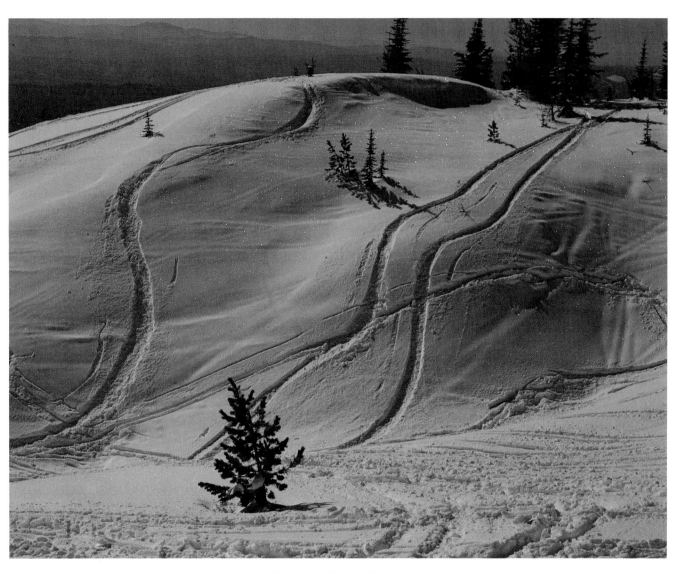

Ski tracks at The Big Mountain

THE FRIENDSHIP OF RAIN

There are times when rain is a bother,
When it turns fields to rot,
Or when it fills in the spot
I have chosen to rest on Alpine trails.

It can drive a mild stream to madness,
As it lashes the last spring snows,
Or when it storms the budding green rows
That had plans for sun before watering.

Parades are never planned with rain
In mind, though a newly cooled street
Appeals to those who have withstood heat
To watch their unskilled prodigy drum by.

Yet rain is a friend of long standing,
Whose faults must be excused,
Lest in its shame it becomes reclused
In neighbors' pastures, forsaking mine.

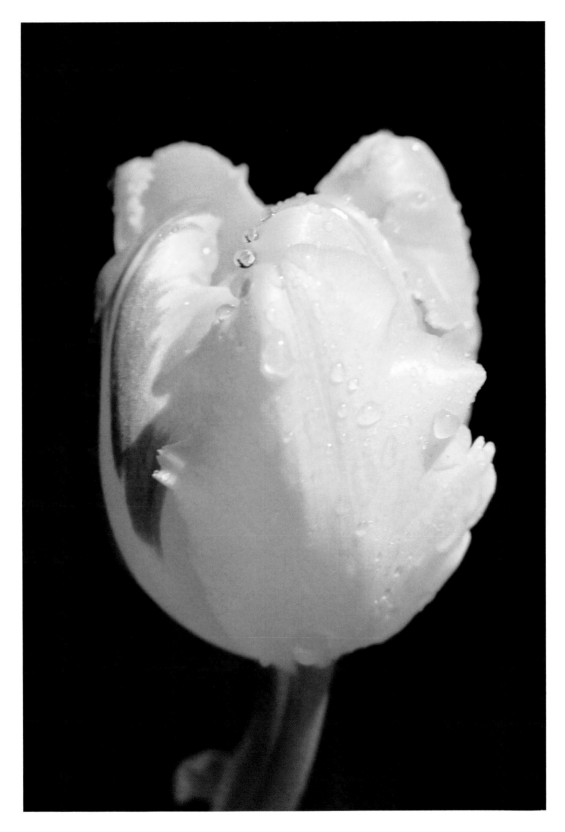

Spring tulip after the Rains

CLOUDS

It is for the blues,

Forming make believe

Silhouettes I await.

Regardless of the torment

Of machinery that level

Man to a deaf mute

In a lemming race.

A fairyland unfolds

In the journey to

A summit unfettered by

Putrid desecration of mankind

Whose only consistent program

Seems to be how best to destroy

The rest in a layer of toxic ozone,

Topped off with the dusting

Of a perfectly insane atom.

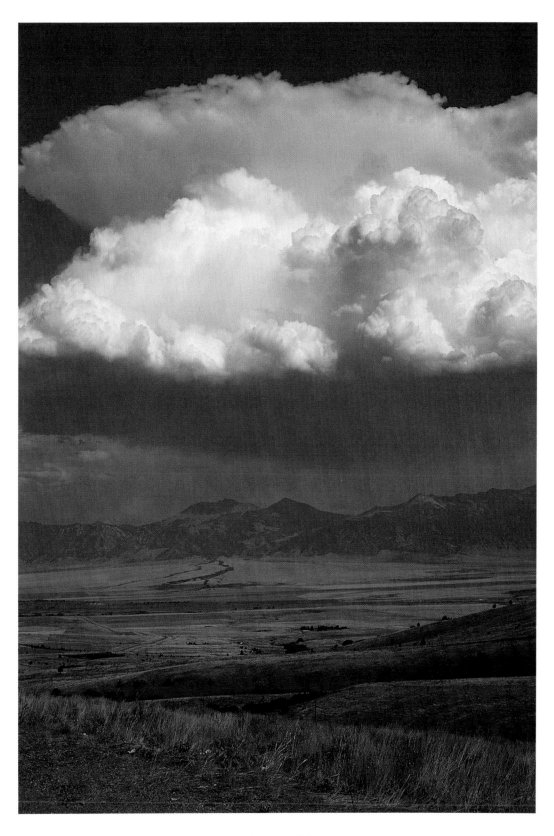

Cloud formation, Montana

27

THE CABIN TURNED TO NATURE

The cabin turned to nature
Long before the Kintla road turned
And plunged into the dark.
Wilderness hands pulled stumps
And dragged them onto the edge of sunlight,
Sculpting home.
Perhaps for a mail-order bride
Who rode a steamer to Ft. Benton.
Stores for winter were stacked
In the splash of burning autumn.
While the bugling elks shifted
To the winter range
Then with a coal-oil lamp and a travel-
Worn bible the mountain lovers settled
Into warmth to await
The rifle crack of spring.
With the melting perhaps a first
Born echoed across the Alpine meadow,
Weaving a completeness
And the loneliness faded to forest.
For countless years it stood
As a reminder of frontier
At the edge of the rising din.
At some point the wilderness children
Faded from the forest.
Later the creator's hands failed
And turned to forest.
The woman wept and left
Perhaps to ride the train back
Into her origins.
More likely she spent her final hours
Wishing those dark logs had never grayed
So that perfect setting might
Have been forever in the road.

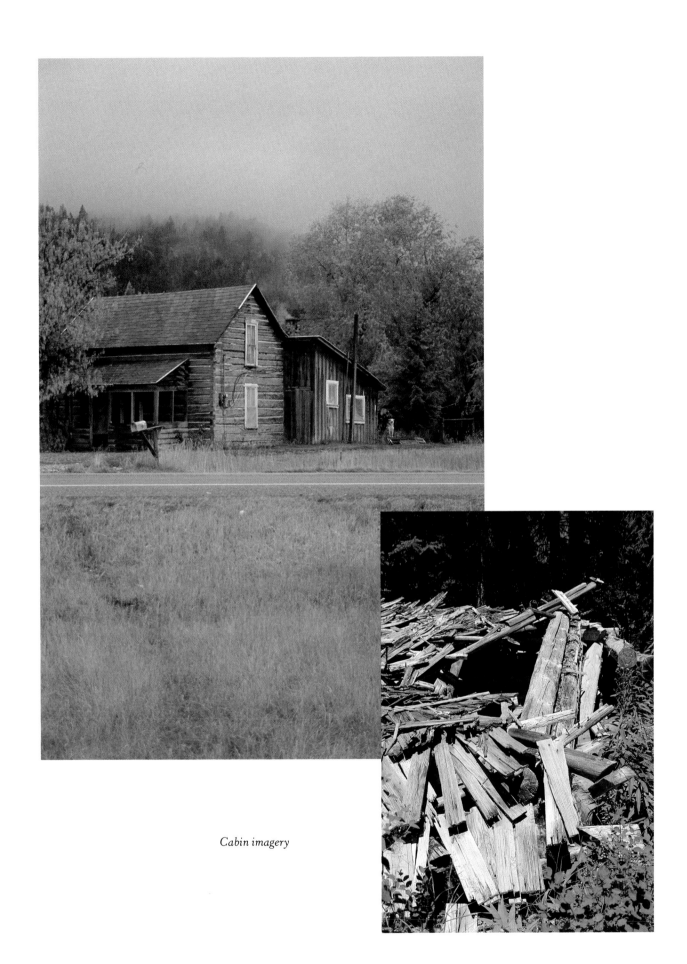

Cabin imagery

A WINTER'S WAY

Man and beast have gone before,
Striking patterns in the snow.
I will follow but a ways,
I hope that you will go.

 See the white blend into the trees,
 Catching the sun's fading glow.
 I'll seek to catch the sparkle,
 I hope that you will go.

 Perhaps in the glen clearings
 The grey running deer will slow,
 I pray to see such beauty,
 I hope that you will go.

 When winter's dark moon moves
 Silently over the floe
 Proclaiming that Time is near,
 I hope that you will know
 That this is my winter to go alone.

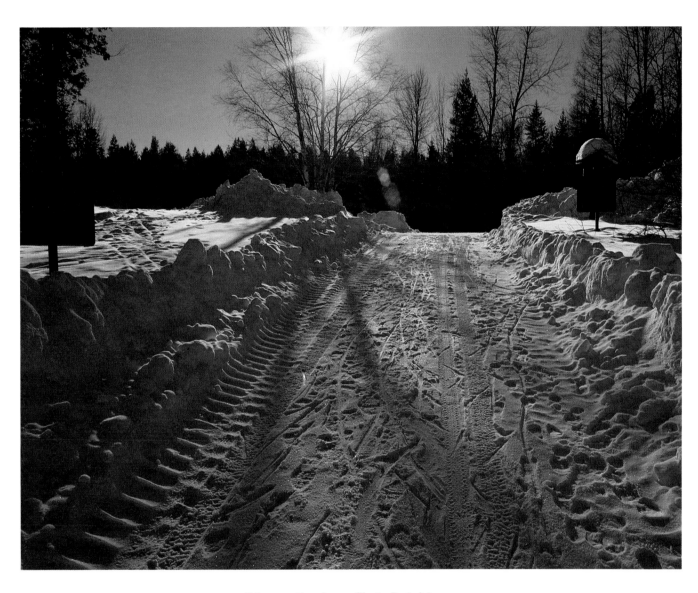

Winter trail at Apgar, Glacier Park, Montana

THE THRILL OF BLOOMING TIME

After the chill of winter has moved

To the other side of the horizon

And spring has shared rain

To reach into the ground,

There comes the blooming time.

 Unlike other wonders of nature

 Or man-made marvels,

 These signals of life seasons

 Require no planning to behold.

 They take in every nook and cranny,

 In backyard patches and meadows.

Unlike most along

Life's way, they are there for

The simple price of not plowing them under.

Some things do not require poetry.

They are.

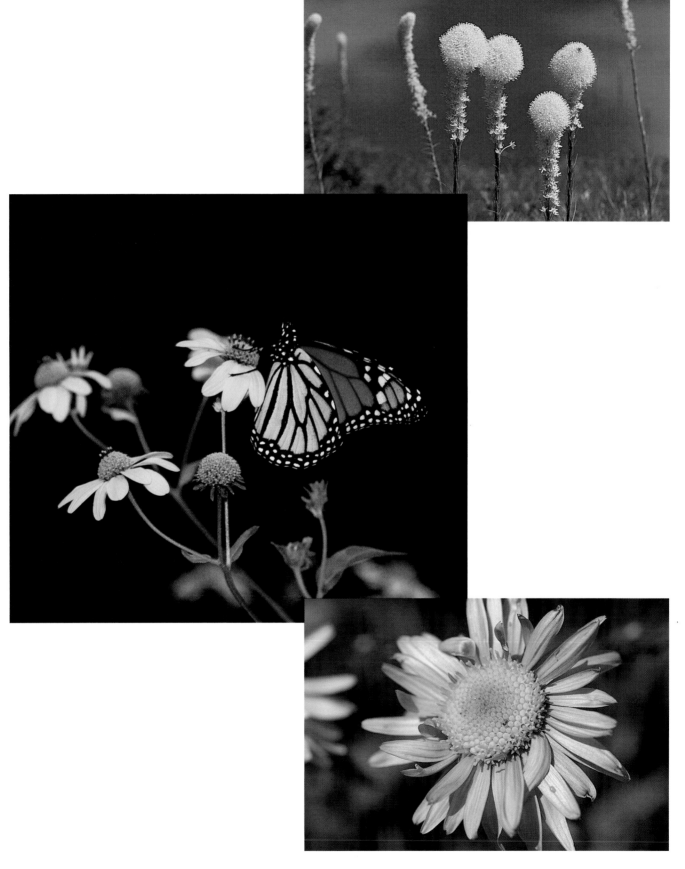

Blooming flowers

33

LAKE MEADOW MYSTERY

Did the woman with honeysuckle hair
Combed in hide-and-seek shadows
Plan her leaving at first light,
Taking the Werner Mt. path out
Through the Ponderosa pine,
Down to the running rails
That snaked toward Seattle?
Did the one-time heller with emerald eyes
That flashed in the hide-and-seek shadows
Sense the impending doom that night,
Ride the Styker River road
Round the Ptarmigan tarn
Down to the free-flowing
Sounds of some city song?
Did the black prancer and his silver queen,
Who danced in hide-and-seek shadows
Race the terror that ruled the quiet,
Moving over the Beaver banks
Up to the winter range
That ran to the ridge,
Spilling the spring snows?
Whatever the reason,
Leaving became a secret compulsion.
I paused at
The entrance to the used-to-be haven.
Set in a perfect picture of
Spring among larch
And whispering aspen, waving
To a hidden breeze, lay
The shambles of water-worn remains.
The house a crumbling reminder
Of futile hopes.
Half hidden by a marshy knoll,
The corral still standing.
Save for a fence section where
Perhaps the stallion stormed.
Now preserved by a watery
Lagoon in the lea of larch
And aspen whispering.
Why would this idyllic spot
Be abandoned, left to ruin
And rot?
Leaving off thoughts
I pondered,
Letting my mind wander over

Plots to fit this lonesome lodgement.
Perhaps at the bending, out of sight,
Man had erected a dam
That backed the lake over the
Shore or some ground spring
Broke through a summer shallow.
The maybe's lay unanswered
In every crook and cranny.
At last the day's candle blew out.
I continued along,
Soon forgetting the enigma
In my reflectings upon problems
That haunt the present.
At the bending of the forest lane,
A one-room cabin
Greeted me and the coming
Night with a shaded light
That glowed through tar-paper windows.
Would the candle lighter know?
Pausing to ask, I knocked.
Peering through the opening, stared
A whiskered, whiskey face
With flashing emerald eyes.
"What happened at the Lake Meadow Ranch?"
"Beavers."
"Surely more?"
"Beavers and the bottle."

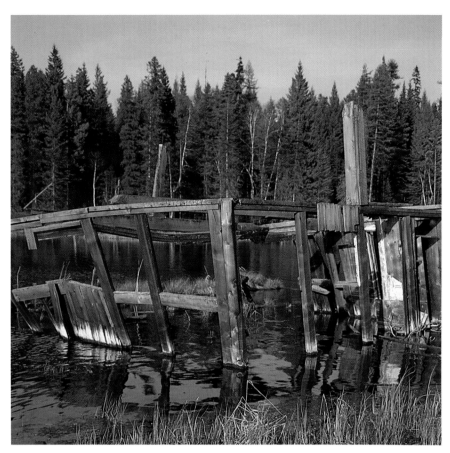

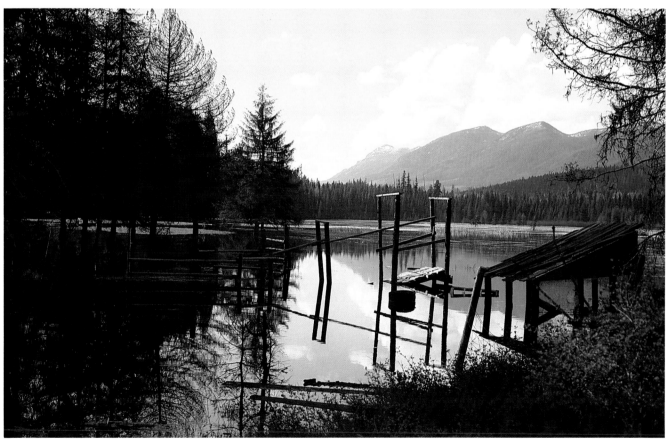

The ruins at Lake Meadow, Montana

CATHEDRALS

I stand in a cathedral of trees

 To give thanks to silence.

I will someday tire of the lonely,

 But for now,

This abundance of nature's muteness

 Fills the void.

The moon snow is neighbor enough.

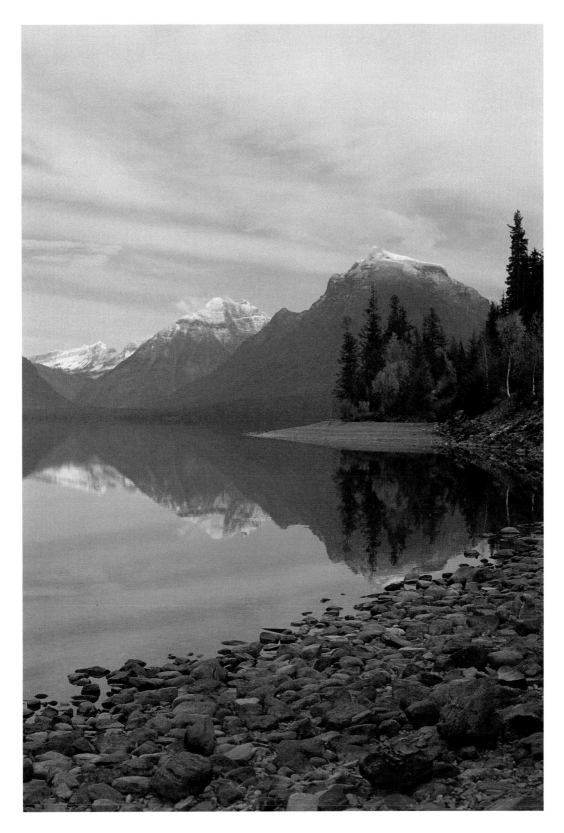

Fall colors at McDonald Lake, Glacier Park, Montana

FEEDING LAKE

I stood at the silent shore,
Reflecting the sun's setting.
At first glance, it held no life,
Simply a sheet of silver spread
Across a forest meadow's bed.
In my frame of mind, it was —
Artistry in flowing strokes.
At a magical moment coinciding
With my leaving,
The unseen stilled, while
A full symphonic complement filled
The valley with songs for a new season.
Hesitating, I paused to hear the harmony unfold,
Lead by a chorus of arch-winged mallards
Blending with smooth singing teals
Followed by the beaver's drumming,
Laced with bumble bee humming,
And the bald eagle, circling, soloed.
Transposing twilight's tranquility
Into a cat calling concert.
As quickly as the beginning sounded,
Came the quiet without climax
Or a final curtain call.
I moved away, but knew
The orchestra would open
Every night of the season
Regardless of the audience.
Nature is content to sing to itself.

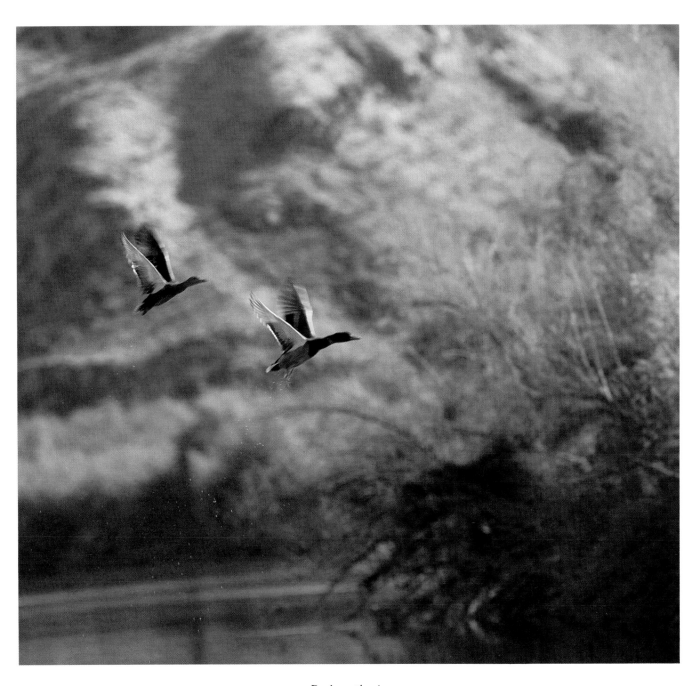

Ducks on the rise

CROW AGENCY, MONTANA

In the shadow of Custer's infamy,
In the bend of the Little Big Horn,
Stands the finality of a treaty —
The Crow's crumbling home.
For thirty miles the highway signs
Give notice of Crow Agency, Montana.
I would have changed the name
Or forgotten the signs.
Shacks and mobile homes
Can't be moved to the summer range.
Beat up pickups are a pitiful replacement
For prancing pintos.
Warriors weakened on whiskey,
Squaws sickened with sores,
Both reminded by the monument
Custer actually won the war.

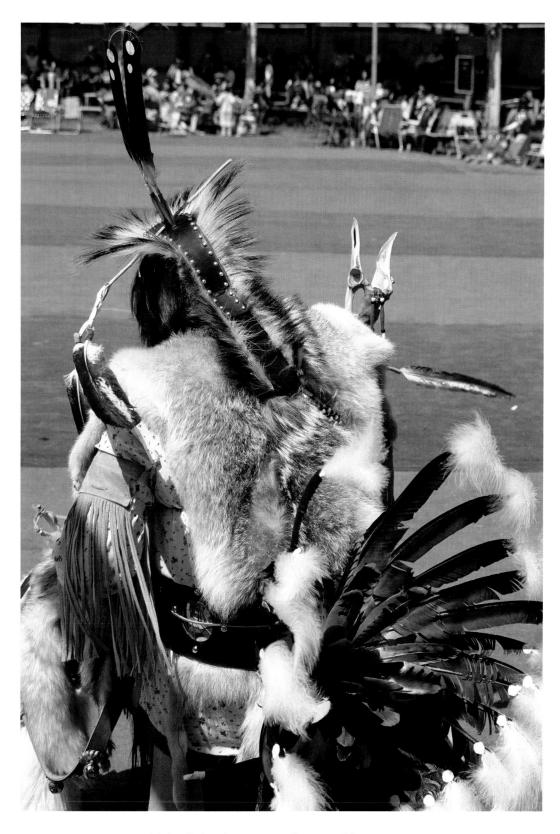

Modern Indian dance reunion, Browning, Montana

BABB BAR

Someone died in Babb, Montana the other day
Probably some poor Indian,
Some whiskey soaked Indian.
They took him to the little wind blown church
On the hill, across from the Harwood Bar.
From there I watched 'em pass —
Leather faced, stone faced, misplaced race
Dressed in their Sunday best.
I guess they stayed inside half an hour,
Then came out and lowered him away.
Ten minutes they were all over here, drinking,
Yelling and the past had closed shut.
He was gone — forever to everyone.
But, I noticed as I left, just on the ridge
Overlooking the grave,
A mournful rag-tag hound.
He's been there four days now.
Christ, I can't have a decent drink for
Watching that old sheep dog
And needing one for having to.

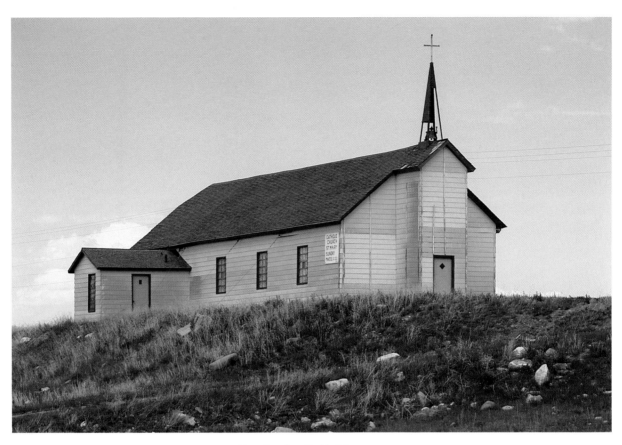

The church at Babb, Montana

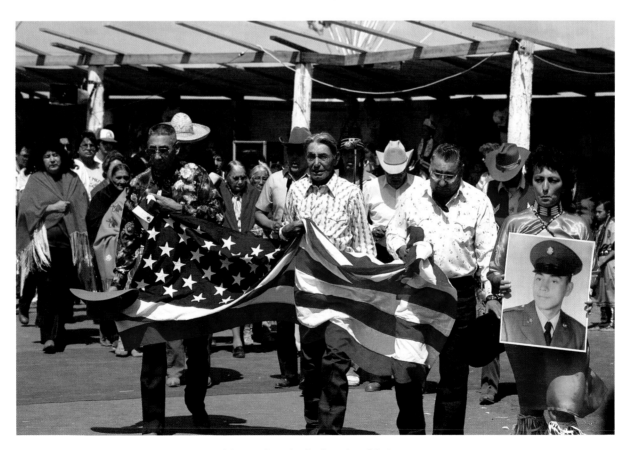

Memorial service for American Native

SEATTLE SUN SETTING

Like whitecaps, running to gold
 Leaping dolphin, clouds below.
 It is dusk, not dark,
 But the horizon's free
 For the bronze to fade beneath the sea.
 Blue,
 Then deeper still,
 Sparkled against Aquamarine
 Streaked with puff Indigo
 Fading to Cerulean.
 There is something quieting about last light
 As it takes on a rusty hue
 And melts the final glow.

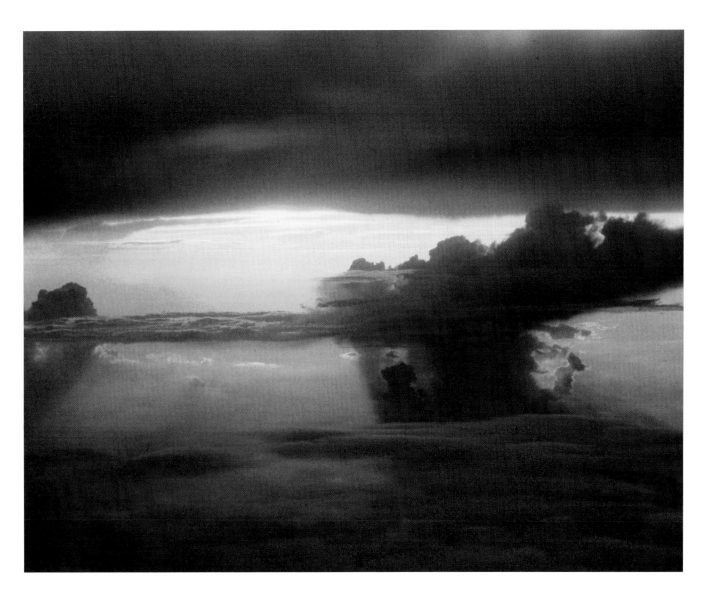

Sunset near Seattle

AT THE ISAAC WALTON INN

How many ways to watch trains?
Some see clanging, noisome power,
Rattling iron and moaning steel,
Piggyback and clickety clack,
Hoppers and creaking coal cars moving
The nation's goods across lonely plains.
Others stop to seek midnight's memory
Of places never seen or since forgotten.
Steam clouds and snow plowed,
Happy hopefuls and desperate daughters moving
Away from dreariness and misery.
Yet truth strikes fool's meditations,
Freight yards and blinking switches,
Shifting grains and clearing lanes are
For the Burlington Northern & Milwaukee moving
Playthings for profit.
Hardware is a harsh reality
Snow, sounds and midnight —
Those are the messengers of imagery.

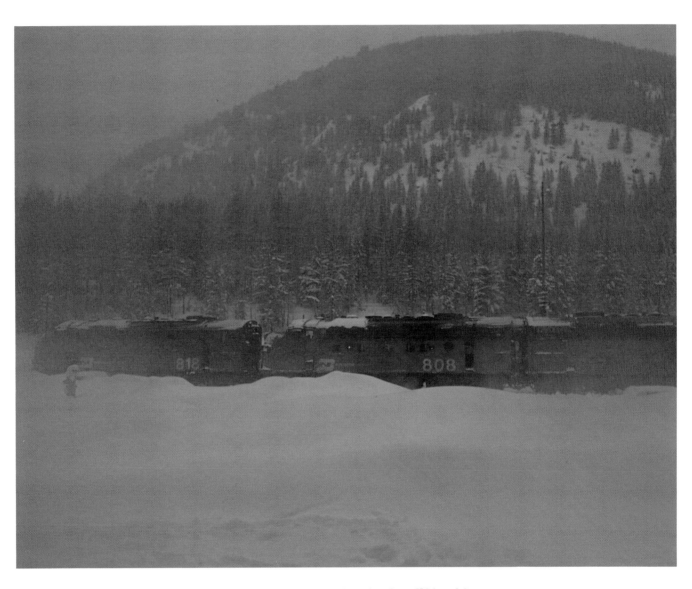

Burlington Northern plowing through at Isaac Walton, Montana

RODEO REALITY

The difference between dreams and reality

Is jeans and dirty fingernails.

> Watch the modern rodeoer,

> Whooping on an electric bull,

> Surrounded by Calvin Kleins,

> Sipping Courvoisier and soda.

Meanwhile, the poor bastards

Who scrape together entry fees

For a chance to be stomped to death,

Watch the flies gather

Around the edge of their day-old beer.

No movies herald their exploits.

No records spin their songs.

These cowboys are dust-busted

As they help each other along,

Across the arena called life.

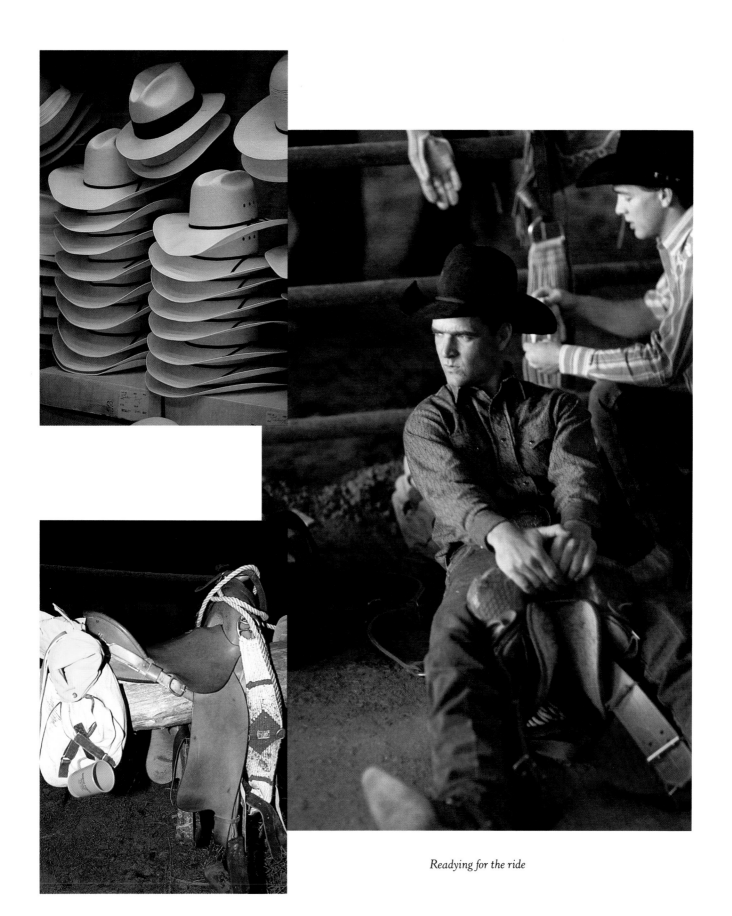

Readying for the ride

WHISKEY WARRIOR

Forgive the whiskey warrior,
His drum will sound no more.
His only link to glory
Is when eagles soar.
For the sky-screamer is the survivor
Of his tragic past.
When the eyrie is silent
He will glimpse his last
Shaft of nobility streak the sky.

> Forgive the gin-soaked grenadier,
> His flag dragged down to dust.
> His only bond to Empire
> A sword that's bound in rust.
> The steel of his dream is sundered.
> Its gleam mocking shadow.
> When the bugle in his mind ceases
> He will cross the floe
> That leads to Heaven's gate.

> > Pity the scotch drenched sycophant
> > Who never heard the drum beat.
> > His only claim to self respect
> > Lay, before his retreat
> > Into the blackness of the bottle
> > Forever lost in obscurity
> > Because no bugles ever blew
> > To cleanse his insanity
> > That leads deeper to despair.

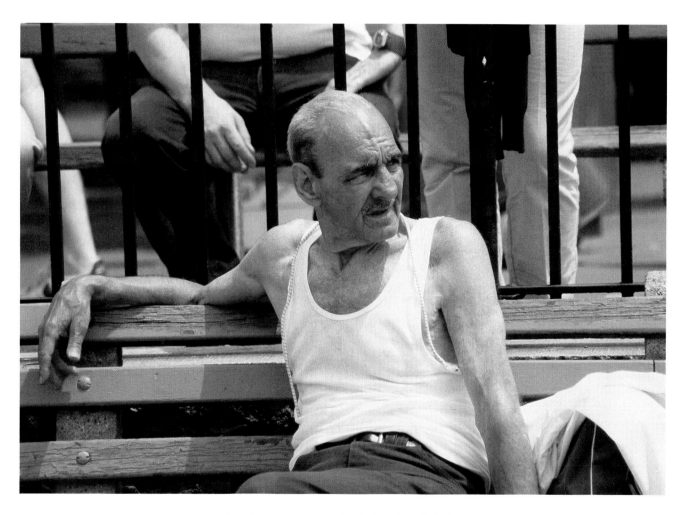

Morning sunning after a hard night, New York City

SAN FRANCISCO BUM

Amid the Sunday strollers,
He bewhiskeredly shook his head,
Scratching at the summer sores,
Not caring how they bled.

He assaulted respectable senses,
As wallowingly he arose.
Out of the rubble and the stench,
Yesterday tumbling off his clothes.

Propped against a trash bin lip,
He matched cigarette to flame,
Stared in silent stupor,
Praying Death would call his name.

Yet even Death has His standards,
Was embarrassed by this beseeching.
Alcoholic misbegots
Were not what He'd been seeking.

So there with dreading hand outstretched,
Cast in filth against the sky,
Sat a soiled sad somebody
Sensing Death had passed him by.

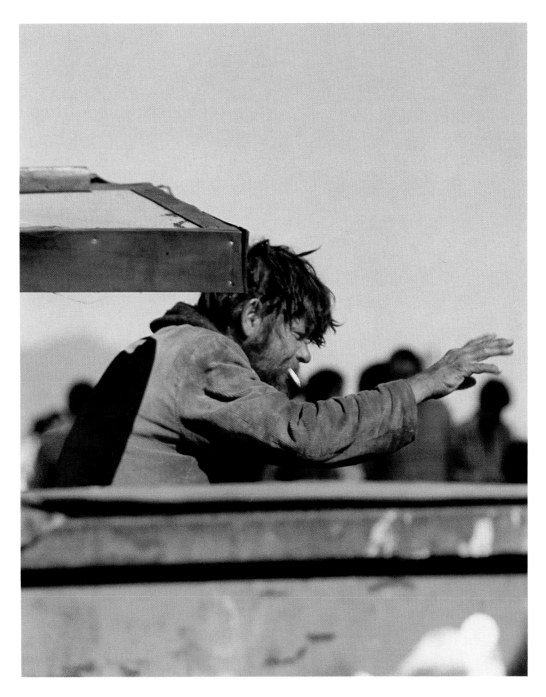

San Francisco garbage dumpster derelict

MEXICO STREET SCENE

Aren't you taken by the color of their clothes?

Isn't there strength in their faces?

The hand crafted dolls are just perfect

Stocking stuffers for Christmas.

Sure you ought to pitch in a penny.

He's blind, you see.

The good news is that these

Proud, self-reliant souls

Will never wade the Rio Grande

With a forged green card.

They'll just sit there in the market streets,

Hoping someone will take their picture.

The problem is you can't look at the images

Without realizing that even if you

Bought a doll or rattled his cup,

You did nothing that would leave an impression.

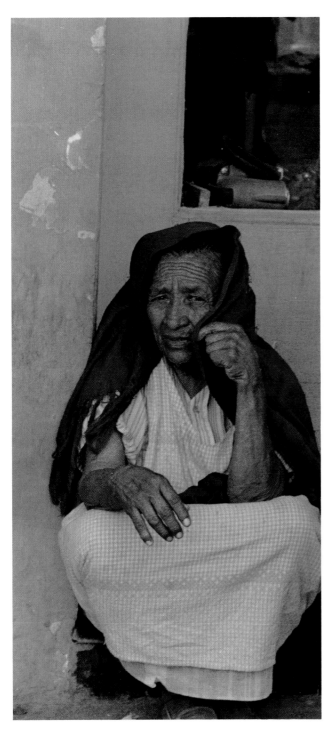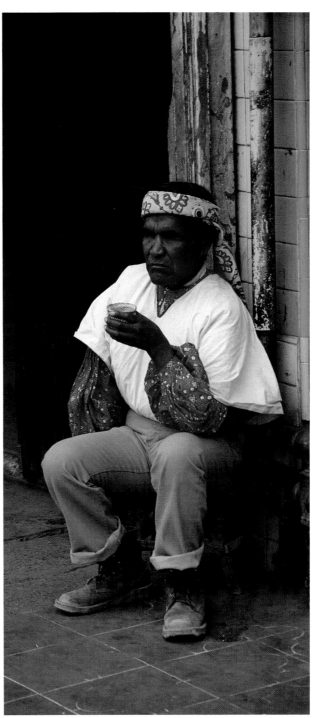

Texas-Mexico Border street scenes

SUNDAY

An organ and blended voices spill
Through the cool morning air.
The comics and football scores
Lie about in heaps, forgotten.
Lawn mowers drone for the last time around
And signify nothing really,
Save the twice-a-year Christian home.
It is Sunday.
The organ and voices are stilled — praying.
Drying clothes flap in the noiseless breeze,
And the neighborhood dogs are at odds.
Cars roll lazily along — that's how it's supposed to be.
It is Sunday.
An ambulance screams three blocks away.
Mrs. Stone probably died.
She'll be replaced by Mrs. Langford's eighth.
But who'll take Mr. Langford's place?
He left a while back.
A couple of blacks are walking
To catch the bus to go across town to church.

It is Sunday. What's the difference come Monday?

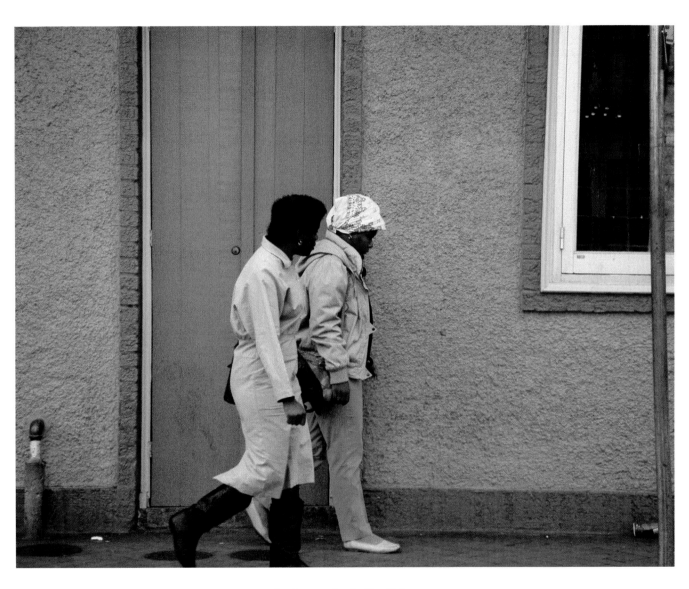

Sunday morning in New Orleans

THE SPIRIT OF '76

Red, White and Blue
Blue, White and Red
White, Red and Blue
Boom, Boom, Boom!

> The land is awash with Red, White and Blue,
> The proud land is sane again.
> The crisis of the recent past passed.
> How preposterous to believe that we
> Could be pulled down by dwarfs.
> Not this Red, White and Blue giant of freedom.
> This living testimony to mankind.
> Maker of dreams
> Fighter for Democracy
> This the August land.
> Steeled by trials in each generation.
> Guided by commandments wrought in blood.
> Even those who besmirched them
> Knew better than to test them
> To finality.
> Lest the specter of mankind,
> Cast in granite in our past.
> Rise in wrath,
> Followed by the people, the Red, White and
> Blue people.
> The Bicentennial's true believers.

I never saw the Spirit of '76 on the 8:09
As it snaked through slums, making time.
I only saw grimy faces and places of gray.
America, where will they celebrate your birthday?

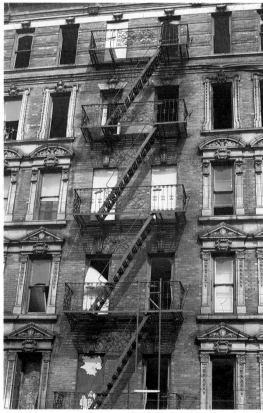

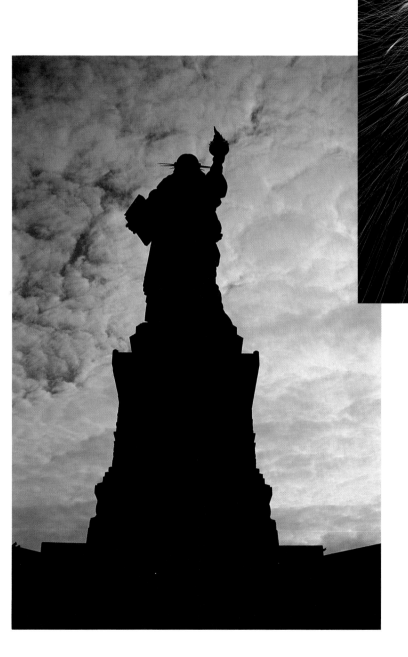

The Fourth of July in New York City

SOCIAL GRACES

There's a lady I know
Who folds her napkin precisely so
Leads each prayer with authority
Using only silver to serve tea.

She sought a husband who,
As most women in her station do,
Would be a perfect match for her
A bland blend in her social whirl.

In time he grew to hate
The very sight of his elegant mate.
For in her precision she never knew
There's more to love than a social coup.

Separate beds, separate halls
Images were kept at charity balls
But pretenses can not hide slight.
He left unannounced late one night.

First she moved to save face
Attempting to hide her disgrace,
But excuses can't veil the apparent
Before gossip ran to column print.

There's a lady I know
Who folds her napkin precisely so.
Today when she pours, her whiskey's
Disguised as finely brewed tea.

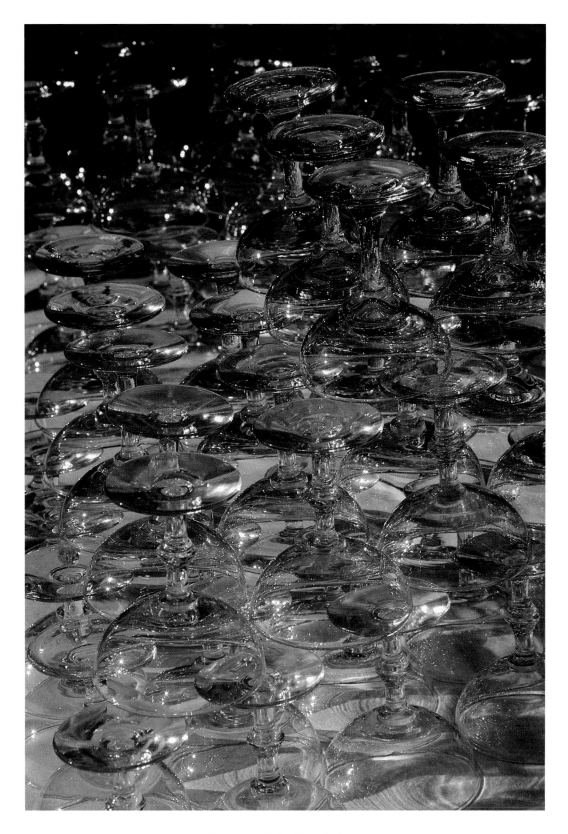

Champagne Cocktails at six sharp

MOMENTARY FANTASY

This is the night
That I will try
To catch the woman
Who caught my eye
While seeming not to do so.

Given the fact
Her gaze was shy
Is all the more reason
When I apply
I hope my intent will show.

So off it is
At the sun's last glint
To conquer a smile
That's left me spent
In its most beguiling glow.

Yet, she may decline
Then what's my reply?
If not yes
But no, then why,
In the first instance, did she wink so?

Ah, this is the night I must weigh
How best to approach
The woman who may
Have blinked in the sun setting low.

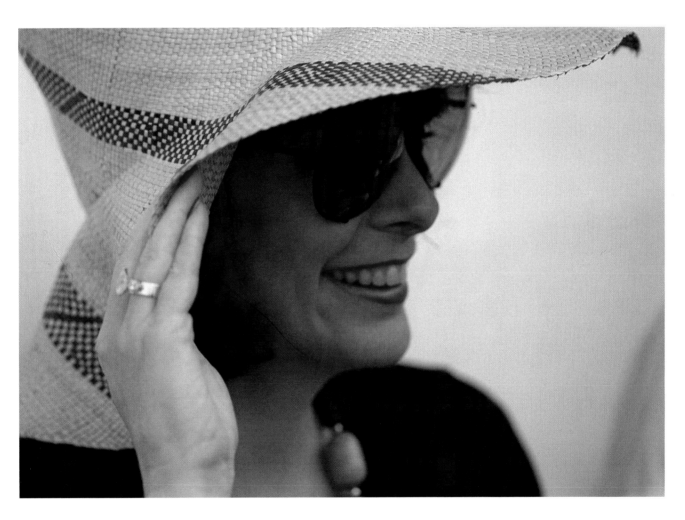

A face in the crowd

PEEK-A-BOO EYES

I get a kick out of the tricks
 People play with peek-a-boo eyes.
 The moment is fleeting
 A split second meeting
 No matter who later denies.

But in that glance, there's an instance
 Telling much about peek-a-boo eyes.
 At once there's a sharing
 In an unforeseen pairing
 Holding an unanswered why.

Yet few ever succumb, nothing's undone
 In looks locked in peek-a-boo eyes.
 Whatever was there
 Soon fades into air
 And saves telling little white lies.

So if you're entranced, then let 'em dance
 Go on, share a peek-a-boo smile
 Forget all the scheming
 Hold on to the dreaming
 It's the mystery that makes it worthwhile.

Flag Football fan

THE GIFT OF A FRIEND

There must be pause for friend

At first light or day's end.

To reflect for the briefest bit

On the reason two fit

Into a mutual frame of mind,

That at best is ill-defined

But is there for the time

When all else fails to rhyme.

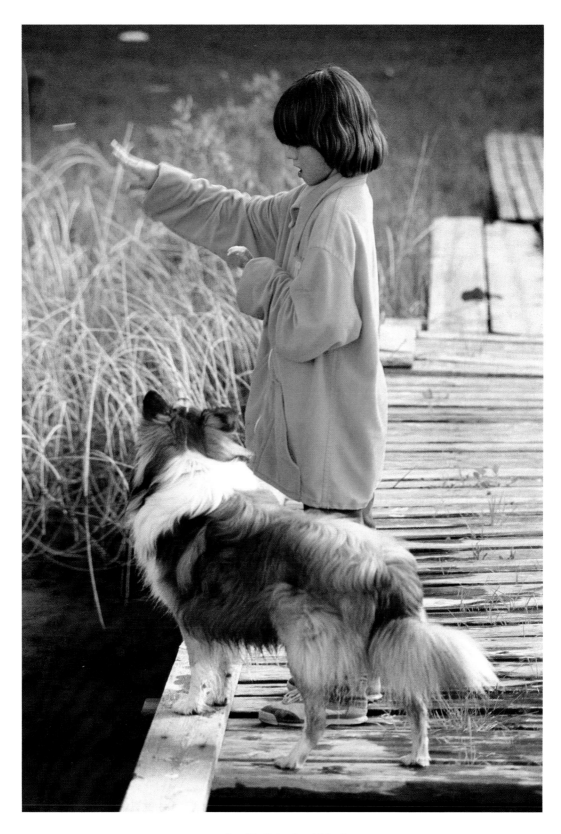

Jennifer Bristol and friend

SUMMER VISITORS

They come from a thousand places
To spend one hour and twenty minutes
Watching the sun settle
On Swiftcurrent Lake.
Then name tagged and numbered,
They move on to the next spectacular scene.
Breaking out their $29.95 Instamatics
To capture a grizzly bear
Approximately three miles away.
Then to a hotel of Holiday Travel's choosing
To rest before they assault
The next glorious day.
I almost made fun of their movements.
Then I realized
That all those bent backs and gnarled hands
Have laid aside $32.50 per month
For all those years to enjoy all of this.
If life has dealt no more
Than a fleeting glance at Glacier Park,
Then it is far better than staring out
A dirty window of an old aged home
Into a parking lot unfilled
With families who never bothered
To understand that growing old
Doesn't mean dying.

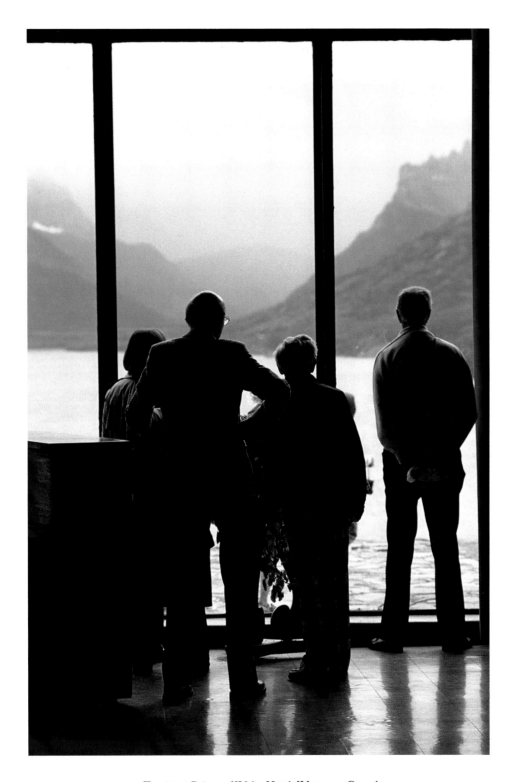

Tourist at Prince of Wales Hotel, Waterton, Canada

THE LADDIE FARM IS PASSING

They'll be coming to the Laddie Farm today
Through the fog and heavy hay.
But after the auctioneer's swift chant is spent
These fields will lay again, silent.

I suppose they'll be selling everything
Leaving only memories in dust rings,
But when the hired hands and taxes are paid,
The subdivision plats will be laid.

The Laddie Farm and family has been here,
Some say well over two hundred years.
But thrown against progress' onslaught
All those dreams will have been for naught.

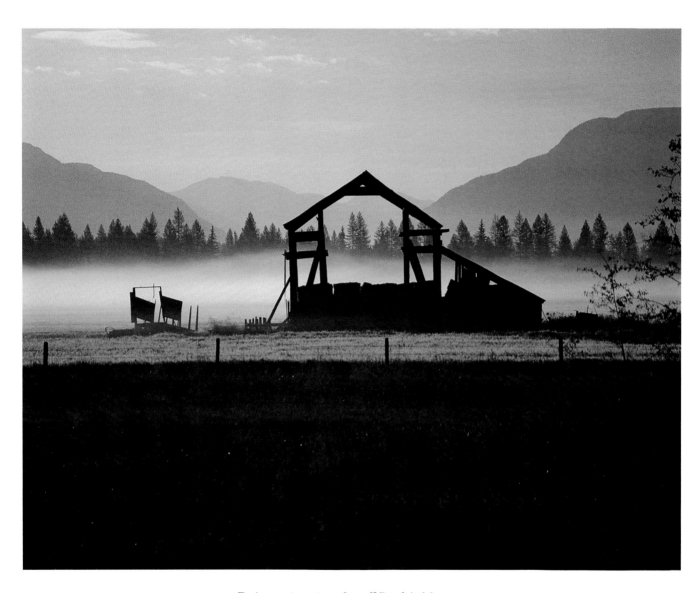

Early morning mist at farm, Whitefish, Montana

THE CIRCUIT PREACHER

Not a single radio beam

Reaches out

For the multitudes

To cling to

And send, no less

Than one dollar

And thirty-eight

Cents, for a

Prayer cloth,

Practically dipped

In the lamb's blood.

Rather by force

Of will and

In the company

Of a hand smoothed

Bible, the true believer

Waits alone for Flight 42

To spring into

The clouds.

I rather suspect

He wishes it would

Hurdle toward

That very distant

Star that he has

Penned a lifetime on.

Saving one point six sawdust souls

Per Sunday must be hell.

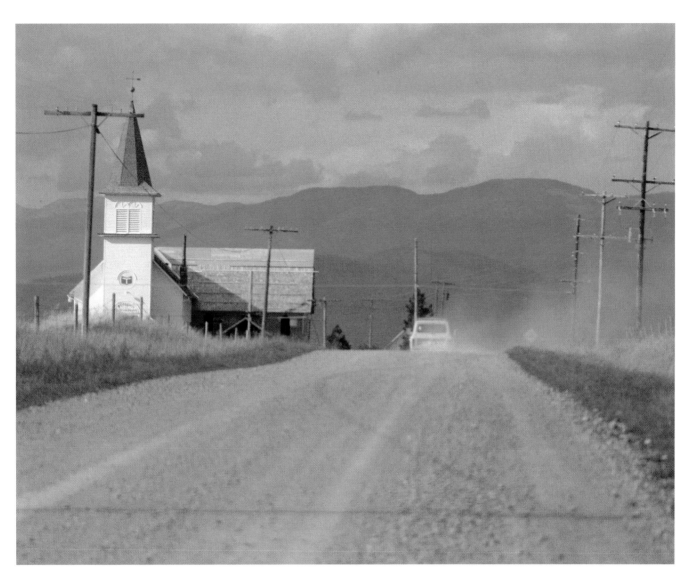

Country church near Whitefish, Montana

OLD SALOONS HAVE LOST THEIR GLORY

Sometime before the breaking
Of another whiskey day
While the bartender's nodding
And baby's on her way.
To help this old cowboy
Drag his boots out the door,
I'd like to feel the magic
Of saloons once more.
See the piano man banging
Them beat up black and whites.
Hurdy gurdies dancing
With some bowlegged Knight.

Old saloons have lost their magic.
Old cowboys have lost their way.

Sometime before the juke box
Spins out its soulful sound
I'd like to see real gamblers
Deal out another round.
Hear the clink of silver spurs
Upon the hardwood floors,
See some dashing desperados
Rumble through swinging doors,
Watch the tin star sheriff call
Some boasting gunner's bluff,
Then tip his dusty stetson
Toward some barroom fluff.

Old saloons have lost their magic.
Old cowboys have lost their way.

But sometime's never coming
Dime novels just ain't so.
Saloons are just for drinking
A place where lonelies go.
Soft music and hard liquor
Were the same, now and then.
Just help to make forgotten
Look like a long lost friend.
Dancers and desperados
Who swung across the stage
Were only painted players
On a faded yellow page.

When saloons still held their magic
And cowboys knew their way.

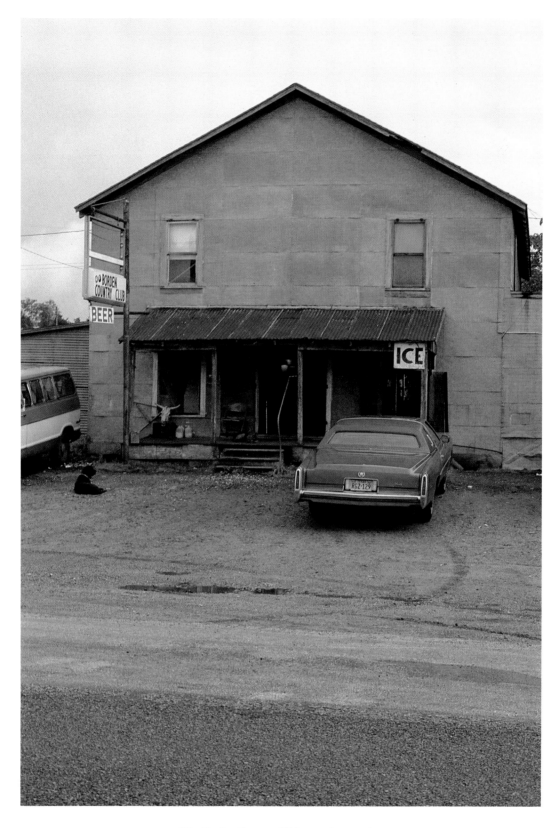

The Borden Country Club on a slow evening

OLD FAITHFUL MORNING

These humble servants of God
Have gathered in His wonderment.
Dressed in their Sunday best,
Not to mention their only.
It is a simple scene,
Peopled by those who spend most hours
Toiling for the glory of His name,
Forgiveness and good grace.
Yet among them there are questions.
Some will never be answered.
Others will come, by and by.
Is there a God?
Perhaps this will remain a mystery,
But on this late summer morning
His work abounds.
The nagging question for me remains.
How did they get here in the first place?

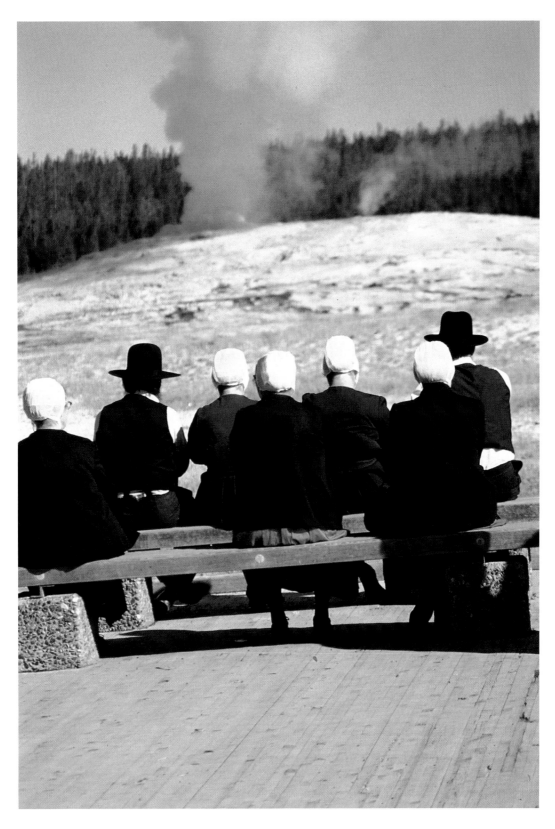

Early morning at Old Faithful, Yellowstone National Park

STIRRINGS

When street scenes grow dark and wet,
Her memory stretches to me, yet
Strange apparitions turn and twist
Confusing our nocturnal tryst
Of so many longing years.

If she could have but shared alone,
Then perhaps she might have known
That her last kiss had lingered long
And that that fever still burned strong
Over so many forgotten years.

Those years enlarge the cast of dreams
To employ what often seems
To be a host of haunting things
That dance on memory's strings
Down the halls of passing years.

So what little time was shared with her
If nothing more than a ghostly blur
In the madness that fills my life—
A single beam shines through the strife
At the edge of fading years.

But there's a time, before sun's first glint
When the watery moon's at last spent
And the dewy light pierces my trance,
Giving her spirit a fleeting chance
To repeal these lonely years.

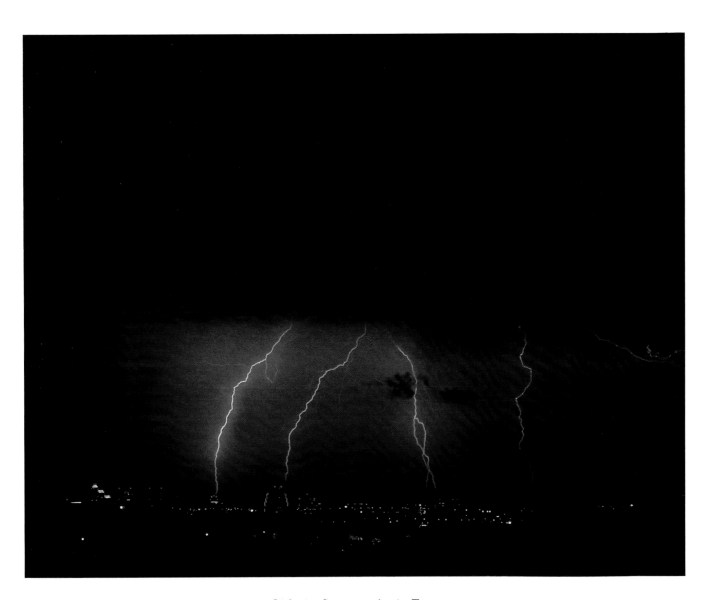

Lightning Storm over Austin, Texas

FIRESTORM RENEWAL

There are firestorm hells
That consume all living things.
After its rage, there's nothing
Save burned out shells.

 What remains are embers
 That settle to await rain
 To remove the dying stain
 Among the timbers.

To the unseeing eyes
The casualty is complete.
Nothing succeeds in defeat—
Only Death replies.

 Yet Death is not the master
 In this stirring to renew
 It is only a way station
 In the black void of gestation
 Before life repeals disaster.

Firestorm renewal at Glacier National Park, Montana

TURTLE BAY OBSERVATIONS

She sits at the end of the lava flow
Watching the waves break and blow.
Why she is there, who can know?
A forlorn figure in pensive repose.

 For all of the morning she's out there
 Letting the sea strip her bare,
 Raking her in the salt air,
 Yet nothing seems to dislodge her despair.

 All day she is framed there in solitude,
 Letting nothing change her mood.
 No sound or sight can intrude
 To break the embrace of her interlude.

 Can she be a haunted, forgotten lover?
 Trying to heal and recover.
 There was more to discover,
 But night lights began to move above her.

So I came here to the edge of the sea
Staring into eternity
And in that lonely misery
I know she is a reflection of me.

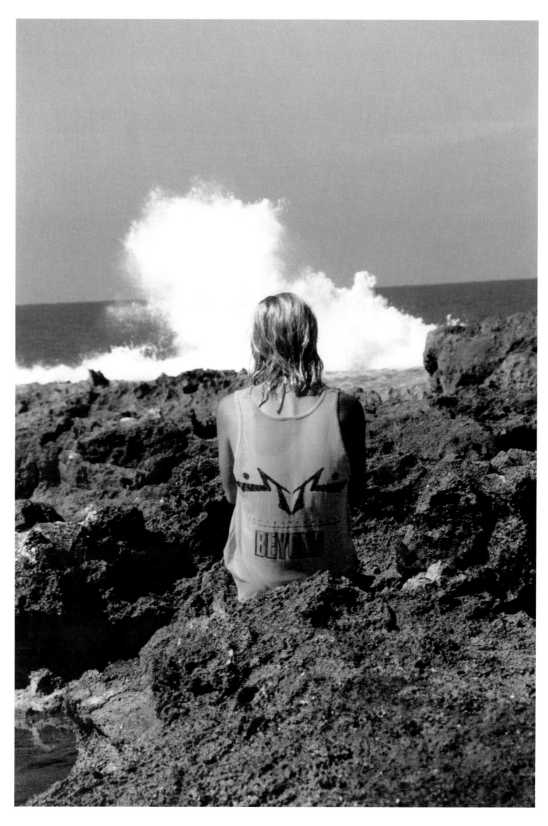

Woman on lava flow, Hawaii

RIO GRANDE COURTSHIP

Tentative, not touching
Silent, yet blushing
Blue jeans and starch shirted.
Sun burned hands, half burned face
That gently began to chat
About arrowheads and yellowed
Plat maps of a time and place
Most often overlooked
By history and latter day travelers.
Serious thought had been given
To gift giving on the edge of nowhere.
For it had to impress, without
A second chance, the eastern educated
Girl and a hovering mother.
Then somewhere in the smell
Of Sunday lava and lilac water,
She mentioned Austin.
He allowed that he'd given
Thought to going there—one of these days.
And if a fellow could go fifty miles
Of dirt road courting,
He sure could head east on Highway 10.
The hovering presence got him back to Indians
And an explanation
About how ole man H. L. Hunt of Dallas
Came to own the cure-all springs—
The Indian Hot Springs.
He wondered out loud just when
They were planning to come again.

>A fellow ought to have proper notice.
>Time enough for a regular hair cut—
>A genuine, El Paso barber shop trimming.
>But anytime, he'd sure be glad to explain
>The arrowheads and plat maps.
>Tentative, yet touching.

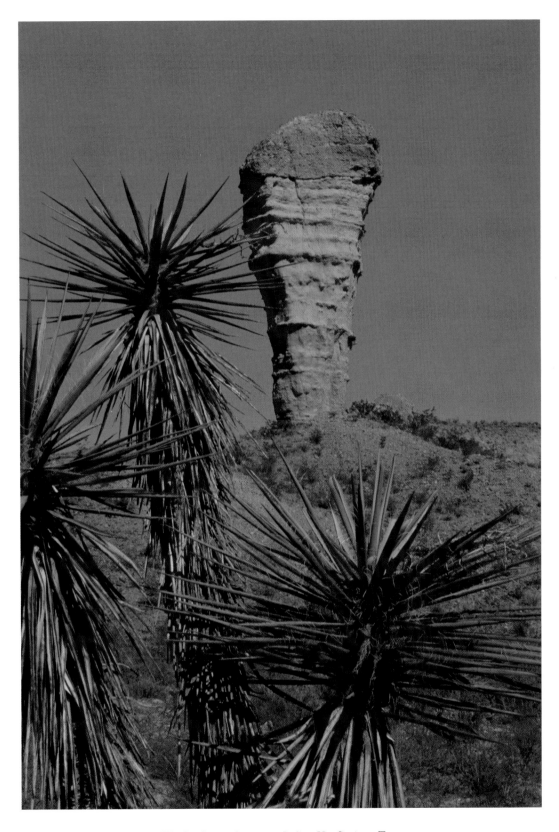

The Ice Cream Cone near Indian Hot Springs, Texas

POIA LAKE REMEMBRANCES

Like old memories, this frame is fading.
Yet enough remains
With some concentration
To place smiles on sun stained faces.
Remembrances of a time
When the pulse of youthful longing
Was enough to fix the future
In that precise moment—
Holding two perfect Earth strangers.

 Now, in the setting of that same glow,
 I sit alone
 In meditation
 To fathom why those sun smiles,
 Swelling hearts and coupled solitude
 Were not enough.

 Ah, well, I still have my mountains
 And summer days to while away
 Hours lost in contemplation
 Of what could have been
 Had motion frozen
 In that single frame of God's camera.

 In these times I realize
 That there is the need for fading frames
 Strung along soon to be forgotten halls
 Saved for those times
 When there is need for reflection
 Or the mind's eye simply needs rerouting.

Poia Lake, Glacier National Park

MOUNTAIN MEMORIES FOREVER

I have had thoughts of you lately,

Dusting at the mirrors of my mind.

Drifting through the musings

Of a fading time

When the monarchs of the Continent

Were sheathed in silver spray,

When the soft smell of summer

Bloomed in full array.

Intently scanning the recesses,

Looking for some glimpse of imagery.

As the mountains in the mist,

The past is a mystery.

Yours is not unerring,

Nothing more than a gentle phantom

Gliding through ghost clouds of Sunday memories.

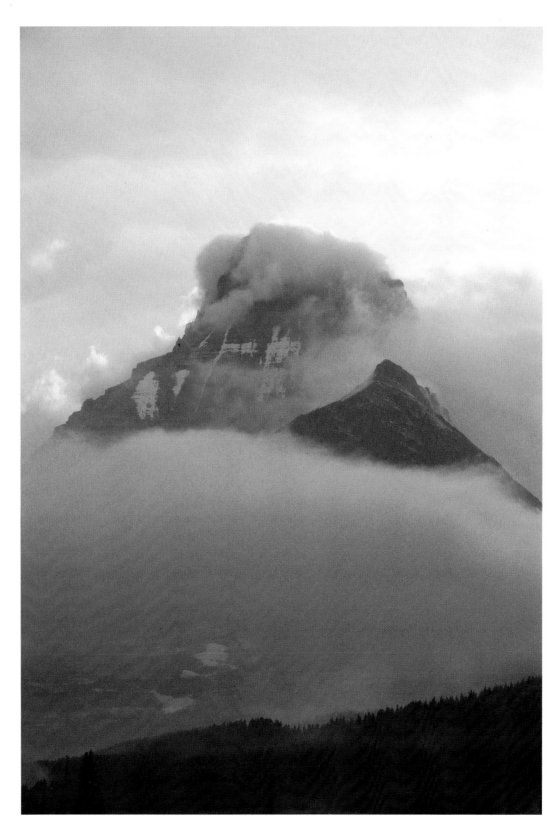

Sunset fog in Glacier National Park

THE BEAUTY OF POETRY

The beauty of poetry is the silence between

The ending of each refrain.

The heart draws from its depth

All that long has lain

In the backwaters of the mind,

Then sparkles briefly beyond the eye,

Warming, saddening,

Harkening back, racing forward,

On to the next ending.

Then fading, perhaps never to be recalled.

But in that unspoken space of a heartbeat

All that man has wished himself to be

Is locked in solid sound and imagery.